SHADOW

A collection of Short Poems

Written By
Anup Baul

Acknowledgements

I would like to express my gratitude to the many people who saw me through this book; to all those who provided support, talked things over, read, wrote, offered comments, allowed me to quote their remarks and assisted in the editing, proofreading and design.

I would like to thank *Createspace* for publishing this book. Above all I want to thank my Mom, and the rest of my family, who supported and encouraged me in spite of all the time it took me away from them. It was a long and difficult journey for them.

I would also like to thank to the members of *Createspace* who have reviewed the work and published it.

Last but not the least: I beg forgiveness to all those who have been with me over the course of time and whose names I have failed to mention."

INTRODUCTION

Poetry is a form of literature that uses artistic and rhythmic qualities of language—Poetry has a long history, Ancient attempts to define poetry, such as Aristotle's *Poetics*, focused on the uses of speech in rhetoric, drama, song and comedy. Later attempts concentrated on features such as repetition, verse form and rhyme, and emphasized the aesthetics which distinguish poetry from more objectively informative, prosaic forms of writing. From the mid-20th century, poetry has sometimes been more generally regarded as a fundamental creative act employing language.

Poetry uses forms and conventions to suggest differential interpretation to words, or to evoke emotive responses. Devices such as assonance, alliteration, onomatopoeia and rhythm are sometimes used to achieve musical or incantatory effects. The use of ambiguity, symbolism, irony and other stylistic elements of poetic diction often leaves a poem open to multiple interpretations.

Some poetry types are specific to particular cultures and genres and respond to characteristics of the language in which the poet writes. Much modern poetry reflects a critique of poetic tradition, playing with and testing, among other things, the

principle of euphony itself, sometimes altogether forgoing rhyme or set rhythm. In today's increasingly globalized world, poets often adapt forms, styles and techniques from diverse cultures and languages.

However the book '**Shadow**' consisting of a good collection of poems written for the children so that they can enjoy the rhyme and get some moral ideologies . The brief notes about all the poems are given below.

A Brief Notes on the Poems

1. **The common Law:-** This poem describes the beauty of nature and the law of nature that one should not break for his own profit. Everywhere there is a law that connects us to happiness but still men entrusted with the same blunder.

2. **Disparity – The Big Question:-** This poem reflects the big issues of the society where we talk about many abstract theories to bring equality, rights etc but the true thing lies with a simple logic that first we have to remove the social beliefs from the society than only it is possible to remove such problems from the root.

3. **Of Memories:-** This poem is all about the memories of those olden days of our childhood school days. The school is like the library of our innocent activities that we did in our childhood. Although we change with the passage of time but the school goes on to update itself with new databases or records.

4. **The Guests of Uninvited Time:-** This poem reflects the changes in ourselves with the time. Once we are so innocent that our speech and activities contains the smell of truth, by then we didn't succeed to hurt others even if we

tries to but now our acts easily hurts other because earlier we were innocent and now we are full with evil emotion and thoughts..

5. **The Cuckoo**:- This is a love poem towards the nature , The poem gives us a message how nature created all her elements for a purpose one such example is the cuckoo that constantly with her abilities soothed our tired heart and tirelessly continued with her role.

6. **Belated Thought:-** This poem narrates our changing wishes and needs according to the different stages of life. How these needs are changing with the passage of time.

7. **The Me :-** This poem describes the role of every person that he or she should play as we have sent to this earth with a purpose and while serving the role neither death can snatch our part. It is not all about to be physically immortal but by our role or deeds we could be immortal.

8. **Corruption:-** This poem describes all about the present corruption in the society and also makes us to realize that it is not enough to simply complain on the issue but to follow our ancestors what they had teach us to cope up with such situations.

9. **Society**:- This poem reflects all the social norms that binds us and ultimately hindering us to get our full rights or equality. This poem acquainted us with the various social issues.

10. **Spring**:- This is a love poem towards the nature , How nature created all her elements for a purpose one such example is the Spring Season that constantly with her talent filled the earth and soothed our tired heart.

11. **Bond**:- This poem narrates the relationship or bond that we have with our parents but later on how the relationship gets breakdown with the passage of time. But we should also remember that history always repeats what we do today in present we have to face the same tomorrow.

12. **What is an Orthodox**:- This poem breaks al the barriers of religious practices and give a new meaning to worship or believer of God, it is not by practicing the religious practices that were written on the scriptures but with a clean mind one can reach to God.

13. **Suppose**:- This poem reflects the eagerness to remove all social evils from

the society with all his supreme power if he gets.

14. **Time**:- This poem narrates the importance of time that if it once goes it never comes so we should utilize each and every moments of our life utilizing the valuable time.

15. **Sharpest Sword**:- This poem reflects the abilities of a pen. It describes how a pen is more sharpen than a sword; A pen can bring any changes in the society that a sword cannot.

16. **I Wonder**:- This poem describe the poet's astonishment on how the evils of the society are still there when we are adopting / practicing so many ways to wipe it out from the society. The poet here searches for the main reason behind it.

Contents :-

Chapters	Particular	Page numbers
1.	Introduction	5
2.	The Common Law	12
3.	Disparity The Big Question	13
4.	Of Memories	14
5.	The Guests of Inevitable Time	15
6.	The Cuckoo	16
7.	Belated Thought	17
8.	The Me	18
9.	Corruption	19
10.	Society	20
11.	Spring	21
12.	Suppose	22
13.	Bond	23
14.	What is an Orthodox	24
15.	Suppose	25

16.	Time	26
17.	Sharpest Sword..............……….	27
18.	I Wonder ………….………...	28
19.	How could I change my destiny	29
20.	Conclusion ……………...……….	30

The common Law

One precedes Two; Two precedes Three
Never Ever they shatter the law to be free.
Too the Nature tag along the unchanged rule
And binds the world in its handful

Spring precedes summer, summer precedes monsoon,
To fill the Earth with its beautiful festoon.
Infancy precedes youth; Youth precedes Adulthood
To accomplish their role set by the God

If such is the common edict
Why men than falsely predict
To be kind towards Nature;
While hideously devastating their own future.

Written by – Anup Baul

Disparity – The Big Question

Oh ! These baffling propositions - Racism, Feminism, Marxism
I know not why these talk about right, injustice and equality,
Although oblivious I'm of these notions but could it achieve the true individualism?
Instead; What I feel the society is still facing with more ambiguity.

They move round and round
Used their hands in all forms,
But under the imperial power still they are bound
Couldn't even comprehend, the world how to Adorn.

However the answer is found with a child
When asked he recommends simply to substitute the name with numbers
To hide the social milieu, which ultimately leads them to exiled
To any Disparity, and leading the issue to disappear.

His innocent reply made me to comprehend the necessity of status in the society
That it was created purposely by us not by our deity.

Written by – Anup Baul

Of Memories

One bright day I saw an acquainted face
With a broad breast and glow in his eyes
That little boy, I could recollect with loosen lace
Who used to be in his usual seat with those loud cries.

Turned now into a responsible man with high titles,
And hold his head with high pride
While trying to seek those unspoken words of his times
To interact affectionately which now he hide.

Those Ugly Scars on my face would utter my words
marked by them and purposely I wear, for which he come
But lost all his hopes to see my newer guard
And gets off melancholically without wishing to none.

I too cries with his dark depart
For I could recreate not our that lost bonding
And remember although days and nights roll but they are apart
One followed other to carry on the story unending.

The next day starts with the rush of all my newer friends
Who begin with their marks on my face
To inscribe their unspoken words that I would remember till their ends
With a hope that they would visit someday and I just could gaze

Written by – Anup Baul

The Cuckoo

Through a melodious song; you wake me up.
Although the day is long; but I begins with a warm up.
I know not where you get such tone from?
You bloom out the mind to obey the nature's norm.
Never you exhaust and goes on serving the earth.
Without any claim brings new songs to its birth.
That filled the mind with beauty utmost
Bringing all the earthly miseries to gets lost.
Hopping from bough to bough on a tree;
For the sake of humanity, gives the labor on free.
And teach a lesson to live unconditionally for other
Where lies the true beauty that we should uncover.

Written by – Anup Baul

The Guests of Uninvited Time

What time has cause to me!
Before she used her innocence to seek my attention
By then I knew much about her
But now she seems to be gone so far
When comes to me on purposed condition
Not even willing me to see

What time has cause to me!
I still remember how she walked on my feet
babbled through my language
But now with a look of abhorrence she only gaze
Upon me and leave me alone on the lonesome street
Although I am hungry, but never asks me for a tea

What time has cause to me!
I speak to me; if it is the law of nature
To weed out the old and replace the new.
Than why the older has only the right to sew
Actually it gives a lesson to comprehend in our future
And understand what we do today shall appear the same to thee

Written by – Anup Baul

Belated Thought.

One Two Three, the stages count we.
Uff ! One after another, Never we are free.
For Infancy babbled for unrealistic Toys;
to decorate their world in their ways.
On being interrupted they began to cry.
To fulfill their desire they do not feel any shy.

One Two Three, the stages count we.
When we started standing out of our knee
Followed Childhood comes with a quest,
Around their peer they wants to be the best.
Fine suggestion seems awful to them
And easily they gets into the trap of Ahem

One Two Three, the stages count we.
"Never gets into the trap", although It's an elderly plea.
But we ignore thought them to be fool
And obstructs ourselves to reach our goal.
Than we blame us for belated realization,
When couldn't anybody perform any action.

Written by – Anup Baul

The Me

I come to the land on the very day of creation,
Time nor death can bring me any castration.
For I have a role to fill the earth,
With my utmost excellence to decorate the hearth.

But if I fail with my physical existence.
I will let the earth with my virtual essence.
And share my experiences with ages,
That what I did in all my stages.

I will ignore the domestic barriers,
And flow on like a brave warriors.
As I know that was all created by imprudent populace,
But the hidden beauties of nature they couldn't trace.

So I will try to grab the chance
Behind those fools who simply dance
And declare that they have DONE
But I know still they haven't seen the real dawn.

Written by – Anup Baul

Society

Mom wearing at all times a white sari;
Why do you peep through the black window?
In any celebration;
I have never seen you willing to go.

Beta! she replied ,White saree stand for a widow;
As to red that symbolizes to a bride.
Who were always welcomed with a bow,
While these are the social norms that we have to abide.

Mom who did create these norms,
Which is only for one
While nobody stood for any reforms?
Just following whatever was done

Beta, it is for our own good
As we couldn't take care of us
Which we heard from our childhood
..

Mom why don't you take care of you,
When you have all the same like a man?
While both have same form and structure as we knew
Why don't you If he can?

Written by – Anup Baul

Corruption

The whole of big ball chatters on corruption
What it is that leaves to us no option
Instead we never wake to avoid such seduction
Fearing to face the opposite action

But we forget the lesson taught us by our master
And in doing so we help the sinister
Although their footsteps always approached in cluster
To wipe out the enemy and to play the role of a duster

Are we mistaken by avoiding their ways
One day I rouse when my mid says
And for my action someday everybody will praise

Written by – Anup Baul

Spring

Blow Wind Blow Wind
With all your efforts
Make us cool, relax and refresh
And take off our stress

When the scorching sun burns everything
You hides beneath the water and comes out
To make the world cool and sing
At night when the curse of sun fall on the sea
Your arrival from the land
Makes us to sing joli bo lee

The big ball moves that gives your birth
For your free service all we are happy on this earth
You make on day and night
To make us free from the summers tight

Blow wind blow Wind
Never you stop
In the months of spring
So can we hop

Written by – Anup Baul

What is an Orthodox

Everybody call me an Orthodox
For I pray daily and makes my sudden sally
While making my move I always chant
The names of Gods with my neck bend

Am I an Orthodox?

For I believe in God as he who keeps us well
And in the final day he leads us to the knell
Neither with his magic nor supernatural power
But we get the hope when we visit his tower

I am not an Orthodox.

For I pray and chant to increase my hope
From my mind that would obliterate all my mope
It is more than a magical power
To stop to become again a cower

Written by – Anup Baul

BOND

I babble and cry for everything
Followed by a serene sleep when you sing
I feel comfort and caring under your shade
If taken away with all my effort I wade
I feel you understand all my need
With a smile you give me breast feed

Now I talk, walk and comprehend
And we are no more befriend
Now I like to hide my thoughts and plans from you
As you yell at me for whatever I do
As I became strong with fierce blood
To get everybody's likes but you fear my guts

Now I pretend to be wise and generous
With a women and children I too became serious
And feel un comfort to keep you under my shade
And treat you as our maid
But when I recall"History always repeats
Than I could realize I have to fill for my deeds.

Written by – Anup Baul

Time

Ding … Dong….Ding….Dong
One, two, three and on, recognizable by my song
Once I go, never can be reversed
It doesn't matter for any of your curse
For some I am laudable
Who goes with me and makes his life admirable
However those who consider me mere a machine
Simply to show the position of sun
I feel sorry; for them nothing could be done
And finally in the fire of guilt he let himself to burn
So consider me not mere a device
I am more than that and never go with lies

Written by – Anup Baul

Suppose

Suppose I could be in a stage to bring truer equality
And wipe out the country's all sort of brutality
Suppose I could bring literacy to all
So to make them stand on the entire ball
Suppose I could make all to eat
To the candles of their life that I can lit
Suppose I could break all the social norms
And make all free out of the storms
Suppose I could break all the racial discrimination
And make them to live together on an abjuration

With these aspiration I stepped to politics
There I found to be in power I need the support of all other sticks
Where each stick has its own strength
Never Could I join them together to expand its length
Without their support how could I fill my aspiration?
So simply it become mere a delusion
Now I can enjoy the power
Where wealth falls upon me as a shower
Now I do not say any suppose
And kept those expectations under my shoes.

Written by – Anup Baul

I Wonder

Sometimes I wonder why men with his other fellow brothers creates enmity
When in our country we talk about Fraternity
Instead of knowing the benefit of unity
They think of for their only community

While development in a truer sense lies in togetherness
That we get it from the Almighty's Bless
Oh God now it is the only you who can remove this clash
As everybody has forgotten the ideals of those olden Days

Written by – Anup Baul

Sharpest Sword

I am credited for beheading many boasting heads
On a paper scattered the blue blood shed
They admire my sharpness than the sword's blade
For I never miss my attack that I made
Who consider me mere a tiny plastic object.
I am more than that which can intersect
Rich vocabulary can sharpen me
And the result everybody can see
Taste your history where I played my role
To make your country free
As I was the only who fulfilled their goal
I am the one who could bring a change
Anybody could trace my range
To remove all those social evils to which we consider strange
So never hate me
For the difference you can see

Written by – Anup Baul

Conclusion

The poem thus revealed the social issues that the society is still facing, that makes us still bound with the social norms

It also reflects the importance of nature; how it helps us in different ways but still we are causing harm to it.

The poem also describes some of the stereotyped ideologies that we bear in our mind.

www.ingramcontent.com/pod-product-compliance
Lightning Source LLC
Chambersburg PA
CBHW070430190526
45169CB00003B/1490